KENDAL
HISTORY TOUR

In memory of my Great-Grandad, Fred Howorth (1904–2000)

First published 2017

Amberley Publishing
The Hill, Stroud,
Gloucestershire, GL5 4EP
www.amberley-books.com

Copyright © Billy F. K. Howorth, 2017
Map contains Ordnance Survey data
© Crown copyright and database right
[2017]

The right of Billy F. K. Howorth to be
identified as the Author of this work
has been asserted in accordance with
the Copyrights, Designs and Patents
Act 1988.

ISBN 978 1 4456 5609 0 (print)
ISBN 978 1 4456 5610 6 (ebook)

All rights reserved. No part of this book
may be reprinted or reproduced or
utilised in any form or by any electronic,
mechanical or other means, now
known or hereafter invented, including
photocopying and recording, or in any
information storage or retrieval system,
without the permission in writing from
the Publishers.

British Library Cataloguing in
Publication Data.
A catalogue record for this book is
available from the British Library.

Origination by Amberley Publishing.
Printed in Great Britain.

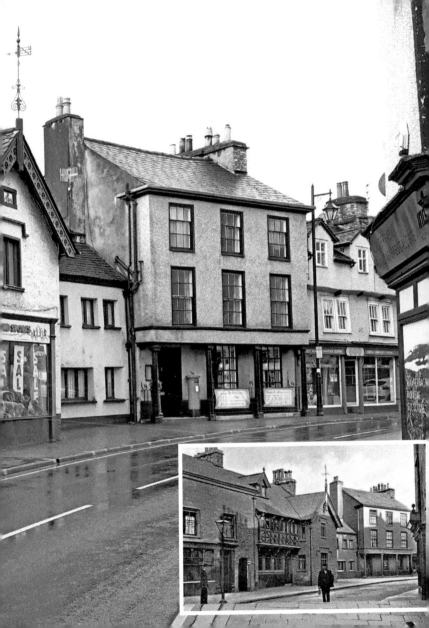

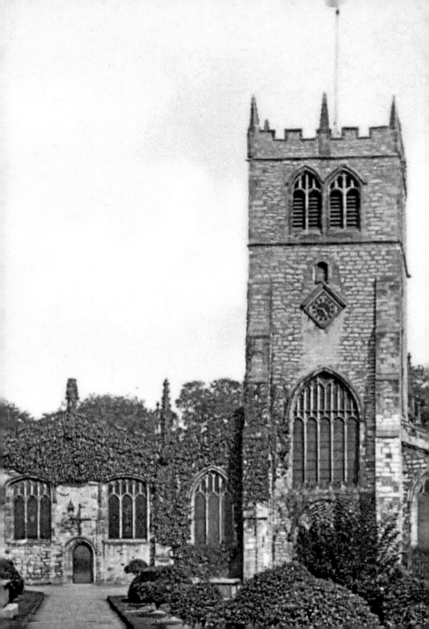

INTRODUCTION

The town of Kendal has a long and interesting history dating back to the Roman occupation. It is known from surviving records that there was a Roman fort located around 2 miles south of the town at Watercrook.

The wooden fort was constructed around AD 90 and was rebuilt around AD 130 using stone. The records also show that during the reoccupation of Scotland during the reign of Antoninus, the fort was abandoned. During the later reign of Marcus Aurelius the fortress was once again rebuilt and remained occupied until around AD 270. In the modern day the remains are now located underneath a field, although some of the artefacts discovered at the site can be seen at Kendal Museum.

After the fall of the Roman Empire we do not find any mention of the town until the Domesday Book. The town is listed in the book as the town of Cherchebi located in county of Yorkshire. The location of the town within the local area is very important, as it is from this that the town gets its name. The River Kent is the main river in the town, which lies in a valley, sometimes referred to as a dale; it is from this dale on the River Kent that we get 'Kent Dale', later becoming Kendal. Early records refer to the town as Kirkbie Kendal, translated as 'village with a church in the valley of the River Kent' and historically the town was part of Westmorland.

The town is notable for its buildings constructed using local grey limestone, earning the town the title of the 'Grey Auld Town'. The earliest known castle in the town dates from the Norman period when the town was known as Kirkbie Strickland, although the most recent castle is Kendal Castle, constructed during the twelfth century as part of the barony of Kendal. The castle is well known as being the home of the Parr family, whose family members inherited the castle during the reign of Edward III and famously Catherine Parr, who would later marry

Henry VIII. Some stories say she was born at the castle; however, there is no evidence of this, as by the time of her birth the castle had fallen into ruin and the family was based in London

Over the centuries Kendal grew to become an important centre of manufacturing in the area with large industries developing around the wool and tobacco trades. The town had a charter market and drew in people from a wide area, which also led to attacks from the Border Reivers, Anglo-Scottish raiding parties. The towns maze of fortified yards allowed residents to find a safe place to hide during these raids.

The tobacco industry in Kendal can be traced back to Thomas Harrison, who, in 1792, returned from Glasgow where he had been learning about the manufacture of snuff. Later members of the family continued the business and several rival businesses were created, some of which are still manufacturing in the town today.

In the modern day, Kendal is most famously known as a tourist town and home of the famous Kendal mint cake, reputedly to have been accidentally discovered by Joseph Wiper during his experiments to create a clear glacier mint. Kendal mint cake became a staple for many famous expeditions, including the supply of Ernest Shackleton's 1914–17 Trans-Antarctic Expedition and Edmund Hillary's ascent of Mount Everest in 1953.

Nowadays the town is well connected to the wider regional areas and major towns of Barrow-in-Furness, Carlisle and Lancaster. Early travellers in the area often complained about the lack of suitable pathways, bogs and dangerous terrain. It wasn't until 1703, under the order of the Barony of Kendal, that surveyors were asked to create roads suitable for carriages, carts and coaches to travel on. Fifty years later the Keighley and Kendal turnpike was opened and brought travellers to the area from Yorkshire. The Lancaster Canal connected Kendal to the network in 1819 and the formation of the Kendal & Windermere Railway in 1847 helped to bring people to the town from all over the country.

This book would not have been made possible without the work of the many writers who over the centuries have written about the history of this historic town, and also the work of photographers and artists who over the past one hundred years or so have recorded the buildings, streets and surrounding area through their work.

KEY

1. Nether Bridge
2. Kirkland
3. Kendal Parish Church
4. The Old Grammar School
5. The Abbot Hall
6. Abbot Hall Park
7. Dowker's Hospital
8. Highgate
9. The Old Brewery
10. Sandes Hospital
11. The Shakespeare
12. The Bank of Westmorland
13. The Town Hall
14. Kendal Bank
15. Titus Wilson
16. The Fleece Inn
17. The Liberal Club
18. Finkle Street
19. Farrer's Tea & Coffee Merchants
20. The King's Arms Hotel
21. The Old Moot Hall
22. The Marketplace
23. Branthwaite's Brow
24. Stricklandgate
25. Carnegie Library
26. Hodgson's Brush Factory
27. Strickland Town House
28. Stricklandgate House
29. Wakefield's House
30. St Thomas' Church
31. House of Correction
32. The Wesleyan Chapel
33. County Hall
34. The Old Library
35. Victoria Bridge
36. Kendal Museum
37. Kendal Train Station
38. The County Hotel
39. The Castle Dairy
40. Stramongate Bridge
41. St George's Church
42. Gooseholme
43. Holy Trinity & St George Catholic Parish Church
44. Kendal Castle
45. Wilkinson's Organ Works
46. Sleddall Chapel and Almshouses
47. K Village

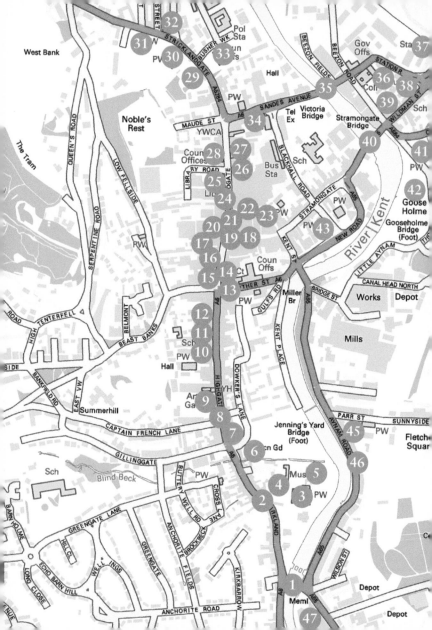

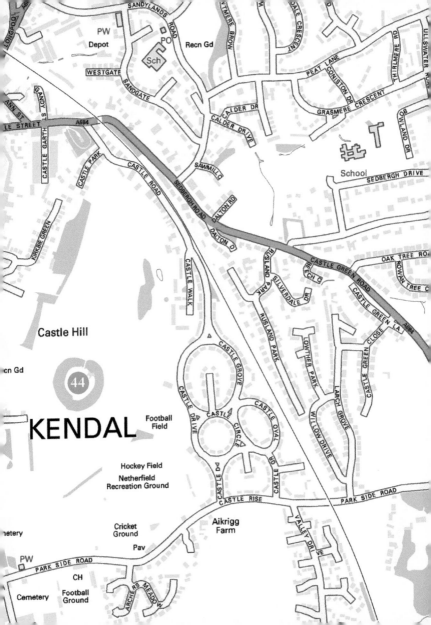

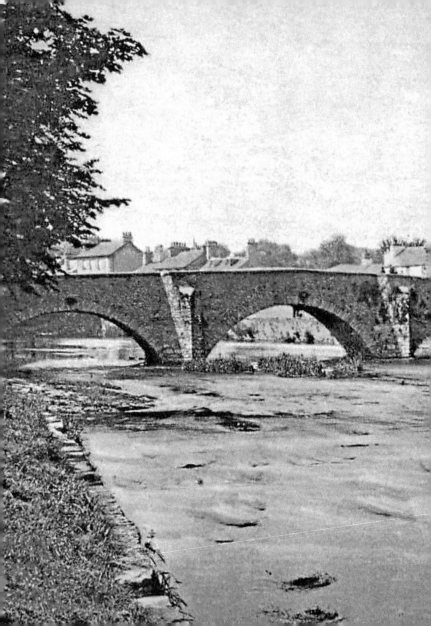

1. NETHER BRIDGE

The bridge was originally the main road into Kendal from the south and was constructed out of wood. In 1376 Edward III granted the rights to charge for tolls for a period of three years, with the money going towards the costs of replacing the bridge, which was in need of serious repairs. Later on during the seventeenth century the bridge was rebuilt using stone to accommodate heavier carriages and an increase in traffic passing over it. It was widened again in 1772, with the final widening taking place in 1908.

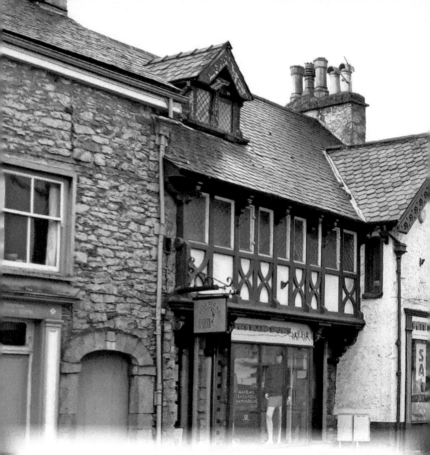

2. KIRKLAND

Kirkland is the main route into the centre of Kendal from the south and is home to several of Kendal's notable buildings, some of which still look as they did centuries ago. Along the road you will come across Kendal Parish Church, the Abbot Hall and its adjoining park, the Ring O'Bells pub and the former post office, noteworthy for its façade held up by four black pillars.

3. KENDAL PARISH CHURCH

There has been a church on the present-day site since Saxon times, but the oldest part of the current church dates to the thirteenth century. The current church was founded in 1201 and is the largest parish church in Cumbria and also one of the largest in England. The church underwent alterations in the fifteenth century and importantly houses family chapels including those of the Strickland, Bellingham and Parr families and the tombs of their family members. Many of the original decorations have now been lost; only remnants of the medieval stained glass remain, with new Victorian windows acting as replacements. The church also houses a fifteenth-century font carved from black marble and a communion table dating from the seventeenth century. In 1854 the church underwent a major restoration, and even in the modern day, the church still plays an important part in the local community.

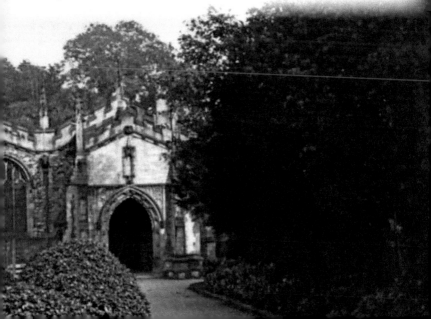

4. THE OLD GRAMMAR SCHOOL

The building that once housed Kendal Grammar School can be found within the grounds of Kendal Parish Church. The school was in use between 1570 and 1870 and was the main educational establishment in the town. The school vacated this site in 1889 and moved to a new premises on Lound Road after merging with the nearby Bluecoat School on Highgate. The school once again merged to form Kirkbie Kendal School in 1980.

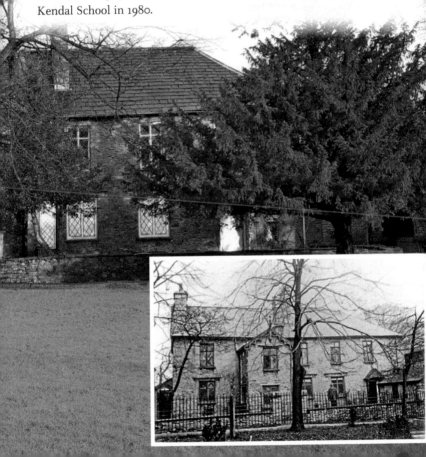

5. THE ABBOT HALL

The Abbot Hall was constructed in 1759 for Colonel George Wilson of Dallam Tower. The architect of the building was John Carr of York. In 1896 the Kendal Corporation purchased the building for £3,750. In the wartime period it was home to a nursery school and later on, in 1962, became an art gallery.

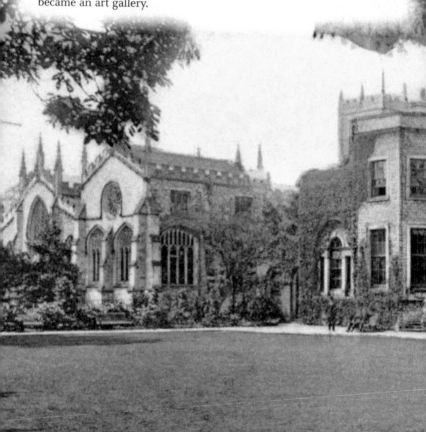

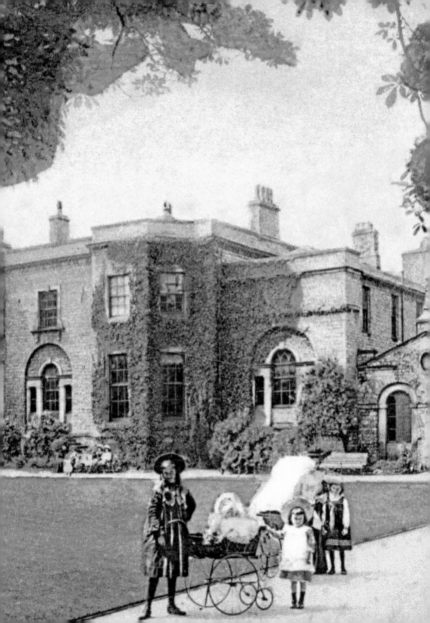

6. ABBOT HALL PARK

Abbot Hall Park, located next to Abbot Hall, is one of the most popular areas of open ground in Kendal. The park opened in 1897 and was partially funded by a contribution from the directors of the old bank for savings. The entrance to the park is marked by an imposing archway. Originally, the park also housed a bandstand, which was removed due to being in a poor state of repair. The park is also home to the Cropper Memorial, dedicated to James Cropper (1823–1900), the last MP for the ancient borough of Kendal.

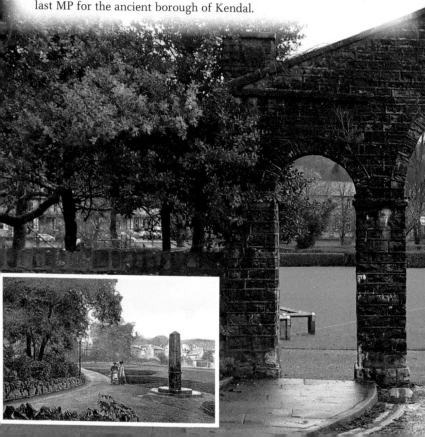

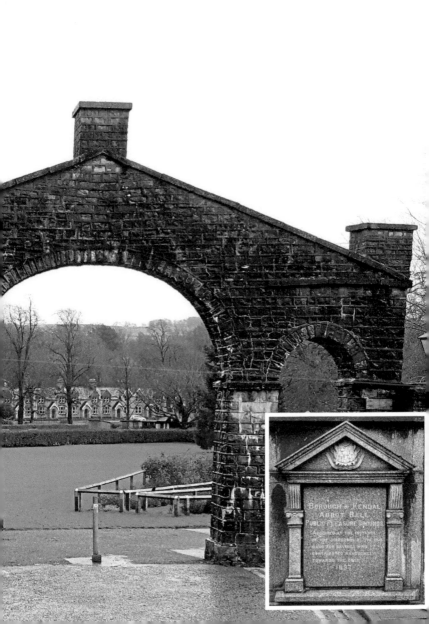

BOROUGH OF KENDAL
ABBOT HALL
PUBLIC PLEASURE GROUNDS

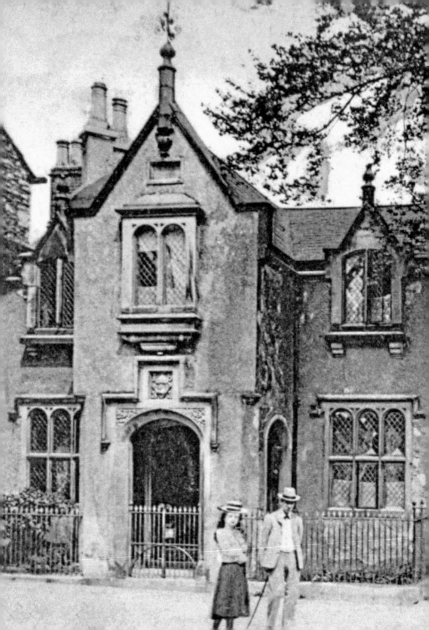

7. DOWKER'S HOSPITAL

The hospital was constructed in 1833 and located at the entrance to Abbot Hall Park. It was designed by local architects Francis and George Webster. It was built as a home to accommodate six 'chaste' women aged over fifty. The building survived until the 1970s when the area was redeveloped and the building was removed. The archway from above the doorway survives and was rebuilt in Webster's Yard.

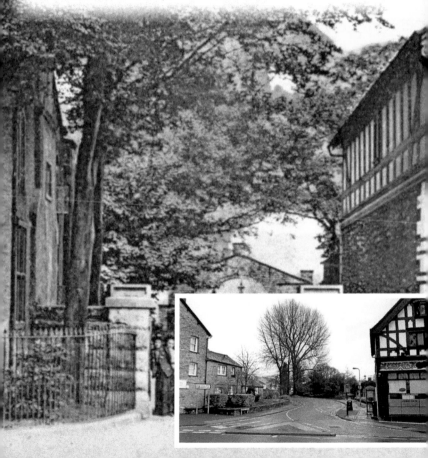

8. HIGHGATE

Highgate is one of the major roads into the centre of Kendal and is home to some of the most important buildings including the Highgate Hotel, the Old Brewery, Sandes Hospital, the Shakespeare Inn and the Bank of Westmorland. If you take a look at the doorway of the Highgate Hotel, you will find milestones marking the distance to Edinburgh (135 miles) and London (258 miles).

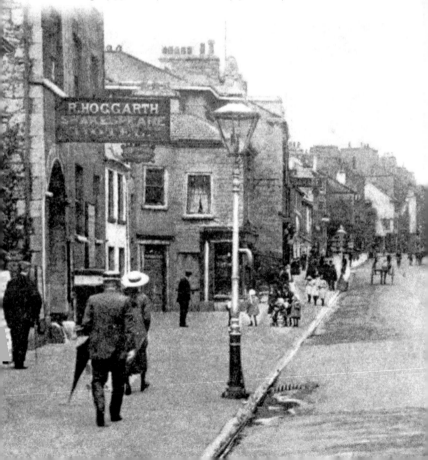

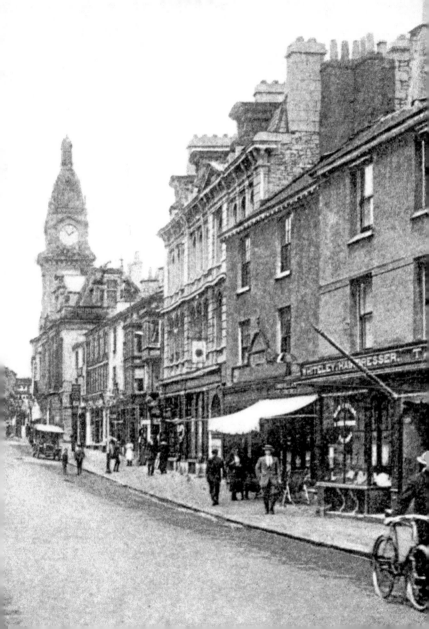

9. THE OLD BREWERY

The original brewery was opened in 1758 by Whitwell, Mark & Co. Ltd and continued its long tradition of brewing at the site through its heyday in the 1930s until 1968. The earliest evidence for brewing in Kendal dates to the sixteenth century. When the brewery closed its doors, it was decided to redevelop the site into an arts venue. The site was purchased in 1970 and two years later reopened as the Brewery Arts Centre.

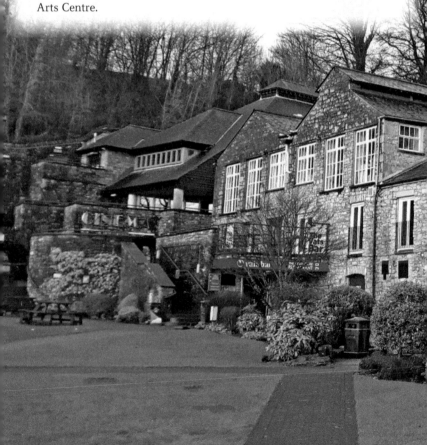

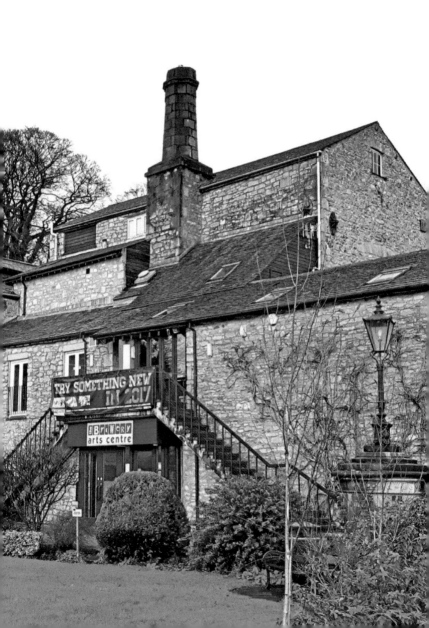

10. SANDES HOSPITAL

Sandes Hospital was constructed in 1659 by Thomas Sandes, former mayor and merchant. He founded a school on the site in addition to eight almshouses. The gatehouse was home to the schoolmaster, with the school and a library located above the gateway. The houses were rebuilt in 1852 by local architect Miles Thompson. In 1886, the Bluecoat School merged with Kendal Grammar School; the school once again merged to form Kirkbie Kendal School in 1980.

11. THE SHAKESPEARE INN

The Shakespeare Inn is one of the newest pubs to have opened in the town. Its name comes from the theatre that was constructed in the adjoining yard and known as the Shakespeare Theatre, which opened in August 1829 and closed five years later due to religious opposition. One of the most unusual features of the building is the small shopfront that faces onto Highgate and is located below the level of the pavement. This shop was home to Wolstenholme's Newsagents for many years.

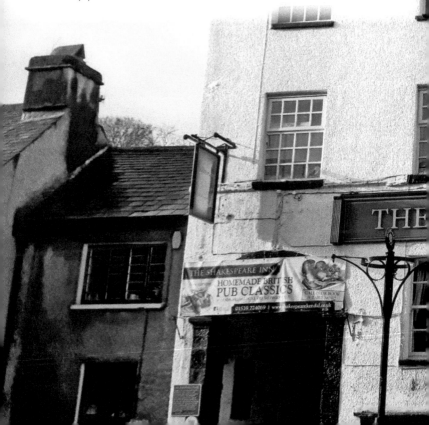

SHAKESPEARE

TOBACCONIST WOLSTENHOLME NEWSAGENT

12. THE BANK OF WESTMORLAND

The Bank of Westmorland was formed in 1833 and moved to its current location in 1835. The building was designed by local architect George Webster. The bank was designed so that it occupied the ground floor, with the upper floor reserved as a residence for the bank manager. The exterior addition of pedestal and lion was undertaken in 1840. The bank became part of the Midland Bank in 1893 and later HSBC Bank in 1992.

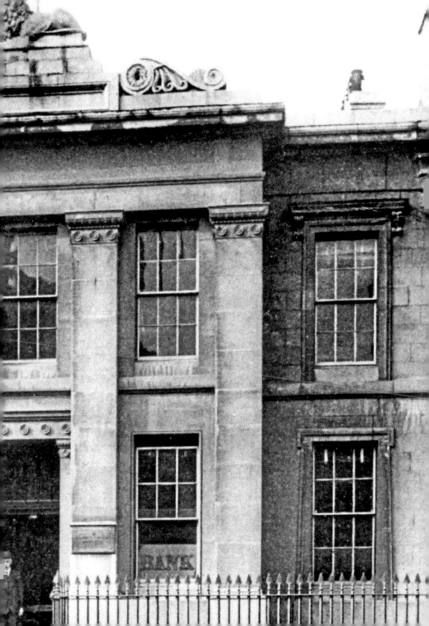

13. THE TOWN HALL

The current site became home to the town council in 1858, when they moved out of the Moot Hall, which was no longer suitable for their needs. The site was originally home to the White Hall, which is believed to have been an exchange for Kendal's cloth trade with Virginia. The building was replaced in 1825 and designed by local architect Francis Webster, whose design also included a newsroom, lecture hall and ballroom. In 1859 the building was converted for use as the new town hall. The building was further extended in 1893 through a donation from Alderman William Bindloss and the clock tower was added four years later. The bells housed in the new tower were first rung to celebrate the Diamond Jubilee of Queen Victoria. At the front of the town hall you will find the Ca'an Stone that was originally part of the old market cross.

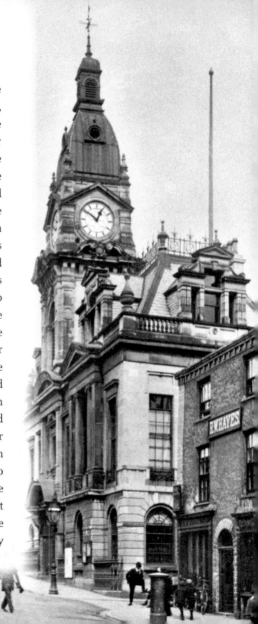

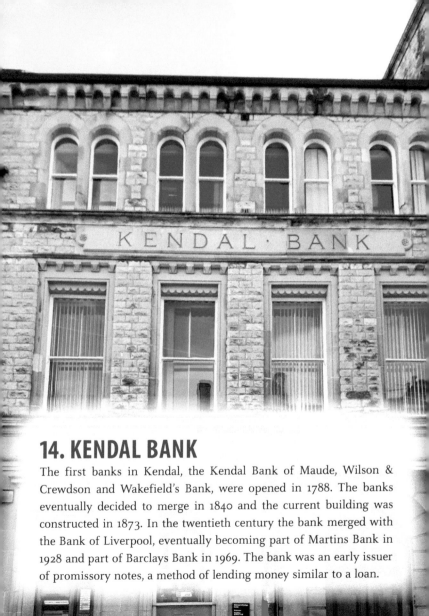

14. KENDAL BANK

The first banks in Kendal, the Kendal Bank of Maude, Wilson & Crewdson and Wakefield's Bank, were opened in 1788. The banks eventually decided to merge in 1840 and the current building was constructed in 1873. In the twentieth century the bank merged with the Bank of Liverpool, eventually becoming part of Martins Bank in 1928 and part of Barclays Bank in 1969. The bank was an early issuer of promissory notes, a method of lending money similar to a loan.

15. TITUS WILSON

Titus Wilson is one of the most famous names in Kendal when we look at the printing industry. The first newspaper in the town, the *Kendal Courant*, was established on this site in 1731, and the business developed and grew to print – not just newspaper but later books. The building that houses Titus Wilson was originally two separate shops – a printers and bookseller to the left and a tobacconist to the right. Some surviving evidence suggests that this may have been the first building in Kendal to use electric lighting. The Titus Wilson printing business is still in operation in the town to this day.

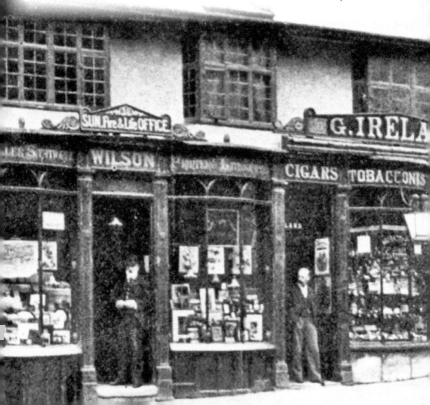

16. THE FLEECE INN

The Fleece Inn is the oldest surviving pub in the town and the building dates to 1654. It is one of the few surviving timber-framed buildings in Kendal. The inn was a popular stopping point for coaches travelling on the London–Edinburgh route, whose passengers would opt to stay at the nearby King's Arms Inn, whereas the drivers would stay at the Fleece Inn. The building originally housed a butcher's shop and first opened as an inn under the name of the Golden Fleece. In 1772 the inn marked the starting point for the county's first stagecoach. Nowadays, the pub retains its original exterior design, which is similar to the old post office located on Kirkland.

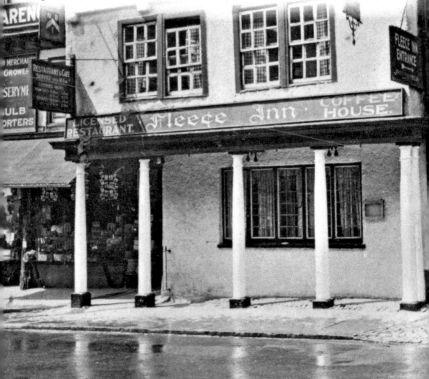

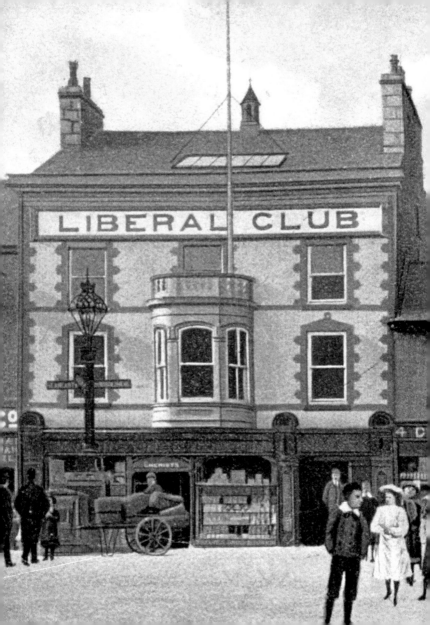

17. THE LIBERAL CLUB

The former Liberal Club is one of the most prominent and notable buildings built at the head of Finkle Street. The building was originally the home of the Crown Inn, which closed in 1880 and later became the Liberal Club. The building remains relatively untouched and can still be found at the top of the street.

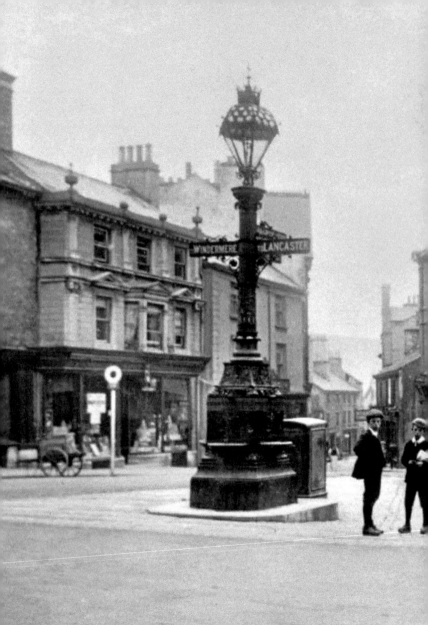

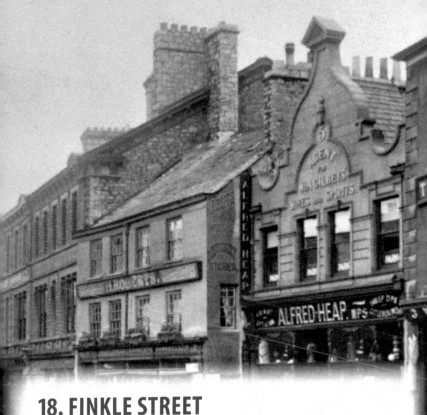

18. FINKLE STREET

Finkle Street was one of the most important roads in the town and was the main road towards the north. It was originally home to the town's fire station, police station and post office. The street also originally housed the fish market, which later moved to the nearby marketplace. The Pump Inn was originally located at the head of the street and was demolished in 1878; the Victorian lamp post marks the location of the original inn, which has since been removed and replaced with the modern structure known as the bird cage.

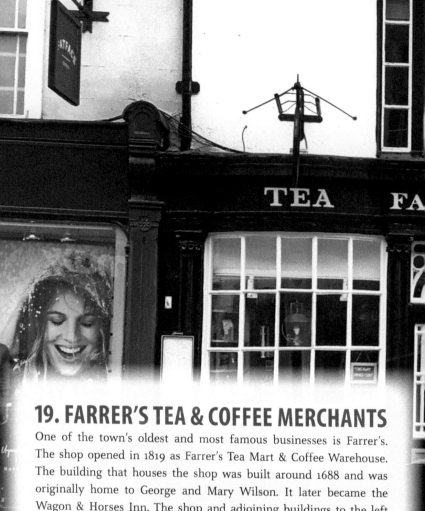

19. FARRER'S TEA & COFFEE MERCHANTS

One of the town's oldest and most famous businesses is Farrer's. The shop opened in 1819 as Farrer's Tea Mart & Coffee Warehouse. The building that houses the shop was built around 1688 and was originally home to George and Mary Wilson. It later became the Wagon & Horses Inn. The shop and adjoining buildings to the left were given new frontages by local architect George Webster around 1822. The building nowadays remains relatively unchanged and still has the original frontage

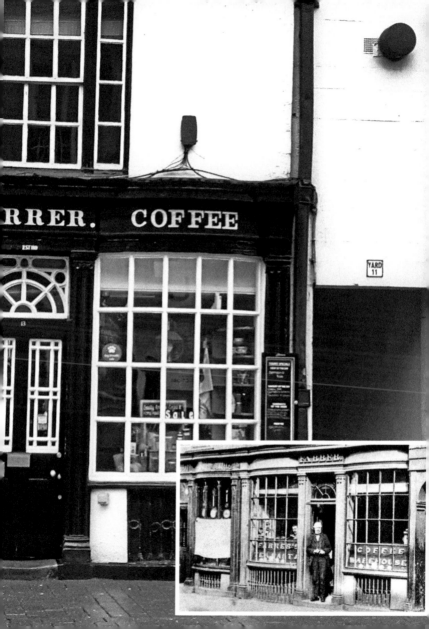

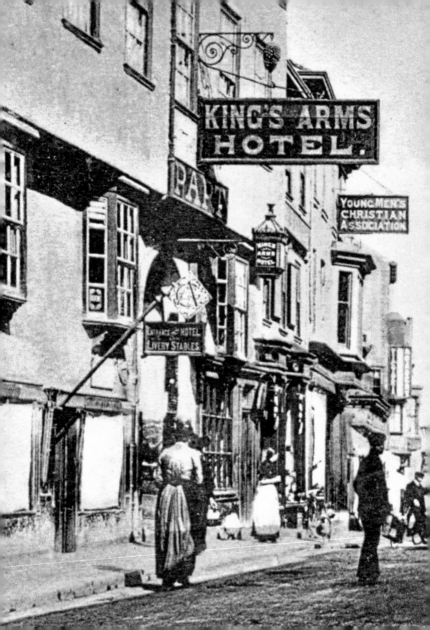

20. KING'S ARMS HOTEL

The King's Arms Hotel was one of the largest and most popular hotels located on Stricklandgate. For centuries it was a stopping point for coaches travelling between London and Edinburgh. The hotel provided food and lodgings for weary travellers and eventually closed in 1936. Nowadays, the location of the entrance of the hotel is not visible – it was where the grey and red fronted store now is.

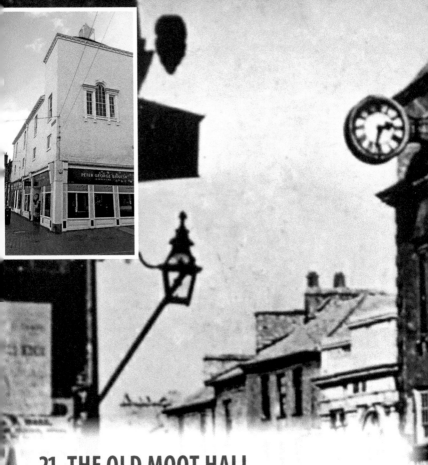

21. THE OLD MOOT HALL

The Old Moot Hall was constructed in 1591 and was originally used as a meeting place for the town council until 1858, when the council moved out of the Moot Hall to Lowther Street. The original structure was destroyed in 1968 by a fire and was rebuilt including a new tower. The original clock was removed and reinstalled on the church tower at St Thomas' Church.

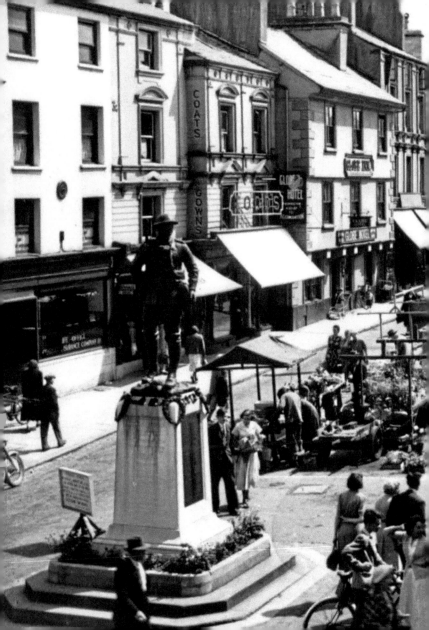

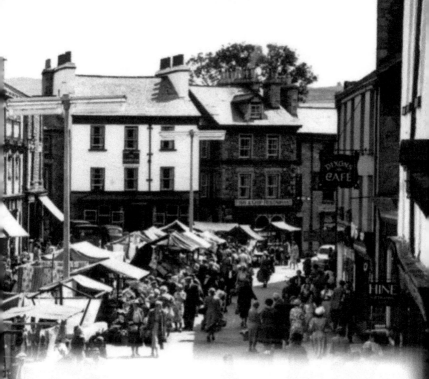

22. THE MARKETPLACE AND CENOTAPH

The marketplace for centuries has been an important centre for commerce in the town. Originally the marketplace was accessible by small alleyways at either side of the old library. The marketplace has housed a regular market for centuries and over the years has incorporated specialist markets originally located in some of the adjacent streets. It has also been home to many popular local businesses and inns including the Golden Lion and the Globe. The imposing cenotaph at the head of the marketplace was unveiled in July 1921 and stands on the site of the old library. The monument commemorates the residents of the town who gave their lives in the world wars.

23. BRANTHWAITE'S BROW

Towards the back of the marketplace you will come across a sweeping, cobbled street known as Branthwaite's Brow, which translates as 'steep road'. One of the most unusual buildings is the small, narrow building with external steps, now home to a chocolate shop. The street is also the home of the Unitarian Chapel and more unusually an iron-clad building constructed during the 1850s.

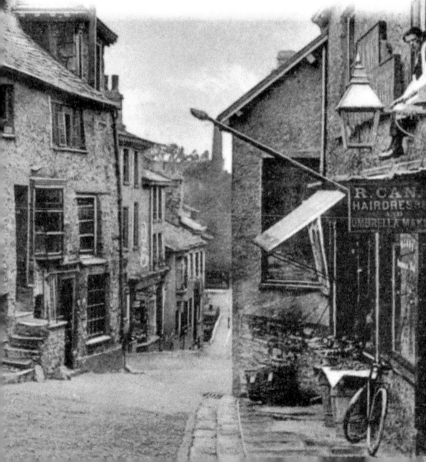

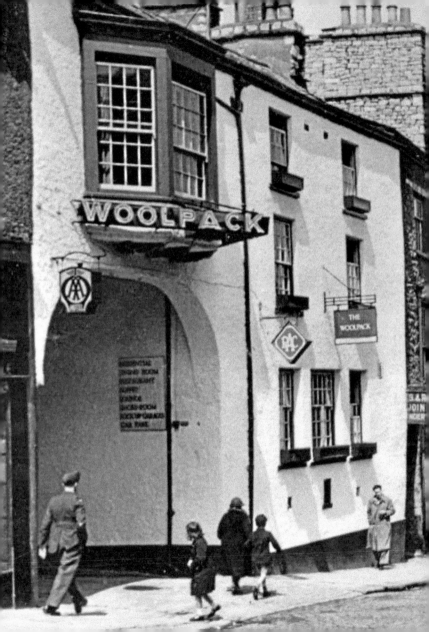

24. STRICKLANDGATE

Another of the important streets in the centre of the town is Stricklandgate, which now forms the main part of the pedestrian area in the town centre. Along the street you can find many interesting and important buildings from Kendal's history including the Old Moot Hall, Marketplace, Carnegie Library, Stricklandgate House and the old brush factory.

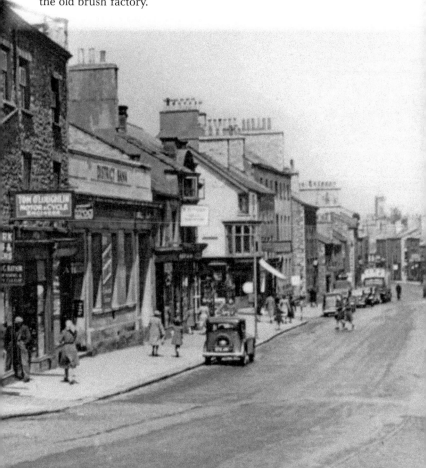

25. CARNEGIE LIBRARY

The library was opened on 20 March 1909 by Mr J. Banks, the mayor of Kendal. The new library was designed by local architect T. F. Pennington and replaced the earlier library that was located in the marketplace. The construction was partially funded by millionaire Andrew Carnegie, who provided £5,500 of the £10,000 needed to build the new structure. The library stands on the site of Brownsford House, a workhouse that was in use from 1725–68.

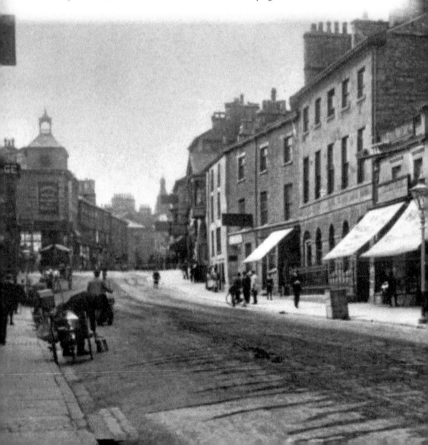

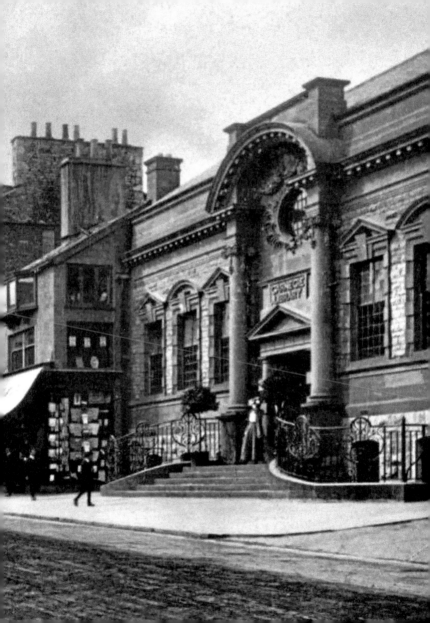

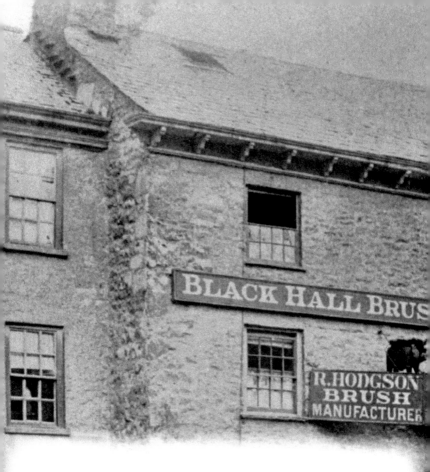

26. HODGSON'S BRUSH FACTORY

The building opened as Hodgson's brush factory in 1869 and was famous for its trade sign above the door depicting a black hog. A replica now can now be found at the site, with the original now housed at the nearby Museum of Lakeland Life & Industry. In 1576 the site was the home of Henry Wilson, the first alderman of Kendal.

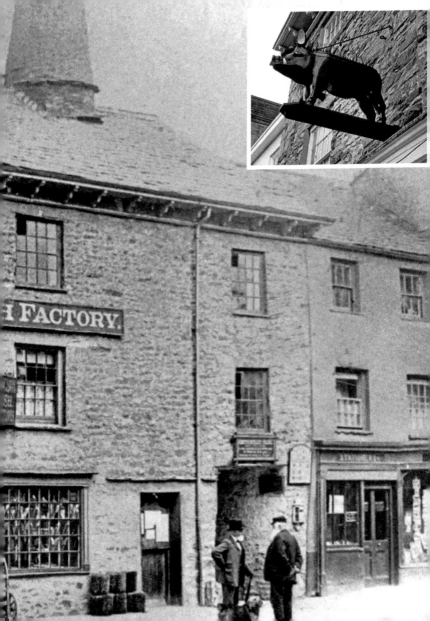

27. STRICKLAND TOWN HOUSE

The original town house was constructed for the Strickland family from Sizergh Castle, one of the most important families in the area. The building was unfortunately demolished during the 1930s and the site is now occupied by the current Kendal Post Office building. Many of the buildings either side of the town house have survived including the nearby Prince Charlie's house and Hodgson's brush factory.

28. STRICKLANDGATE HOUSE

Stricklandgate House was constructed in 1776 by Joseph Maude and was the home to the Kendal Savings Bank. In 1854 it became the home of the Kendal Literary and Scientific Society, founded by several notable men including William Wordsworth. Later on it was home to the Kendal Museum until it moved to its new home on Station Road in 1914; however, the building has remained relatively unchanged since its construction.

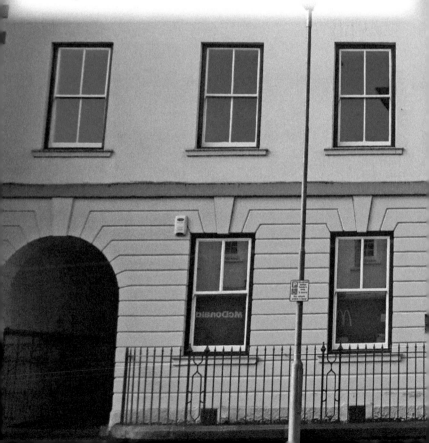

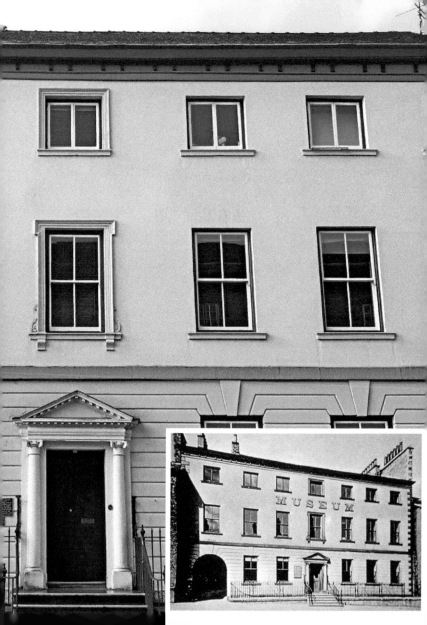

BE JUST AND FEAR NOT

29. WAKEFIELD'S HOUSE

This house has been home to one of the town's most famous families for over 350 years. The house was built and owned by the Wakefield family, who have lived in the house since 1665. They are famous in the town for founding their bank in 1788. Other notable family members include William Wavel Wakefield MP, hereditary peer and sportsman who later became known as Lord Wakefield of Kendal.

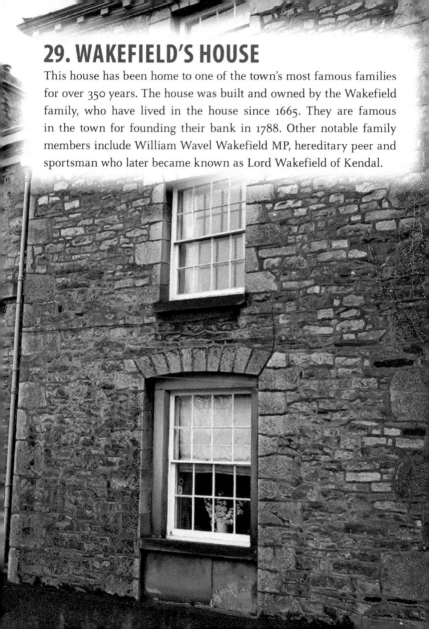

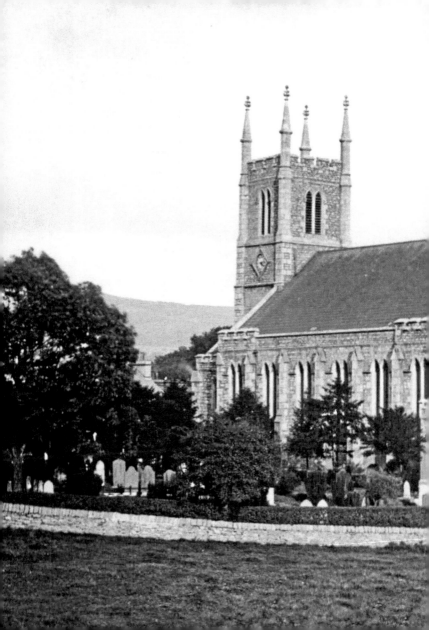

30. ST THOMAS' CHURCH

The church was constructed by local architect George Webster in 1837. Unusually, due to problems with drainage on the site the building is constructed the opposite way round, with the altar facing westwards and the tower at the eastern side, which is also a feature that is shared with Webster's Holy Trinity & St George Catholic Parish Church on New Road. The main clock above the entrance was originally part of the Moot Hall.

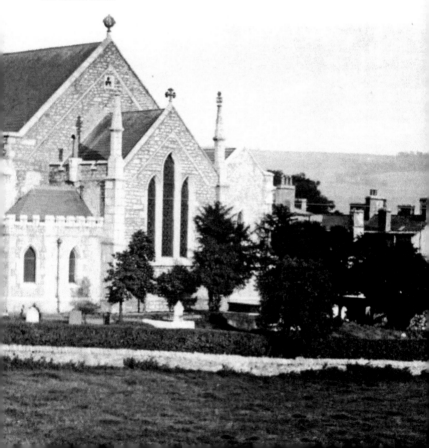

31. HOUSE OF CORRECTION

The origins of a prison on this site date to the 1580s and was later expanded in 1817. The prison was accessed from Queen's Road and was a huge development. The prison had walls were over 12 metres tall and almost 1 metre thick. The site was later used to house military prisoners from 1894 and eventually closed its doors in 1900.

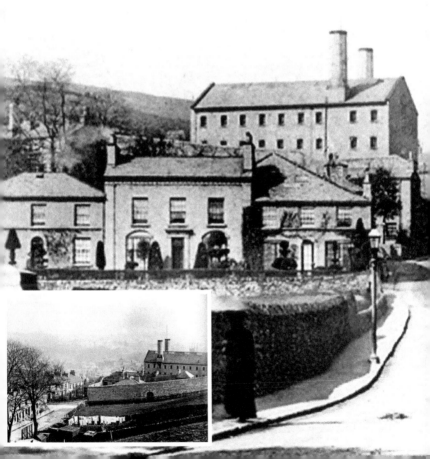

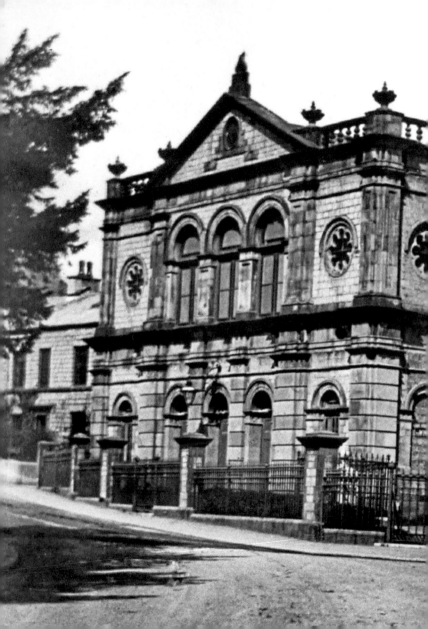

32. THE WESLEYAN CHAPEL

The Methodists have a long history in the town, and from the surviving records we know that Revd John Wesley first came to the town to preach on 9 April 1753. Later on the Kendal branch of the Methodist society was formed and their meeting place was the Old Play House in the marketplace. The church then moved to a new site in Stricklandgate before moving to the current site where an earlier chapel was built in 1808. The current chapel opened on 29 March 1883.

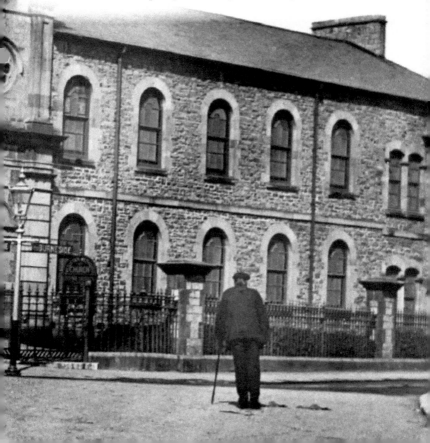

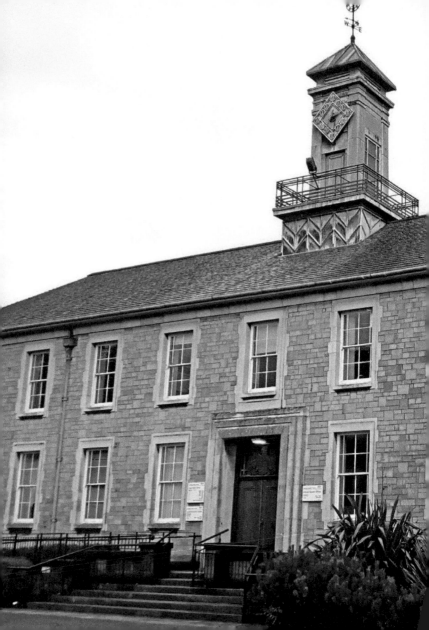

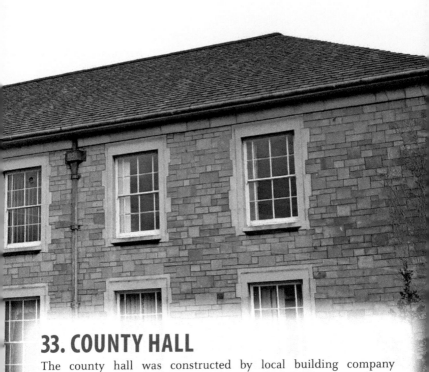

33. COUNTY HALL

The county hall was constructed by local building company
E. G. Martindale in 1939. The building is notable for its unusual clock
tower with a balcony. The building is now used as the meeting place,
offices and archive of Cumbria County Council. Above the door the
coat of arms for the County of Westmorland can still be seen, which
was incorporated into the county of Cumbria in 1974.

34. THE OLD LIBRARY

The first library in the town opened in 1847 and was located in the north-west corner of the marketplace. Later, in 1891, a new public library opened in the converted market hall at the entrance to the marketplace, where the cenotaph now stands. The building closed to the public in 1909 when the nearby Carnegie Library opened in Stricklandgate. It was decided the old library building would be dismantled, the front and side façades being kept and reassembled as one frontage on Sandes Avenue.

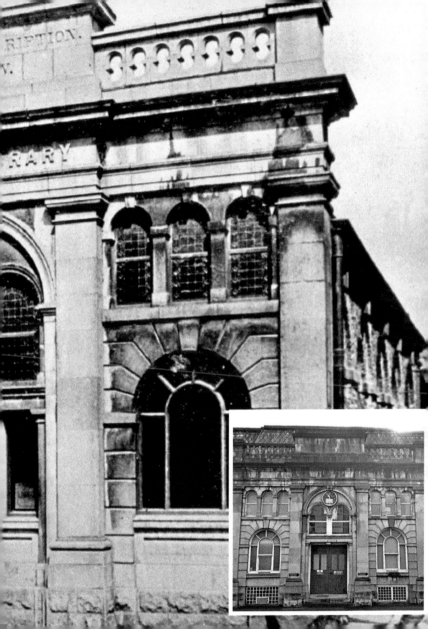

35. VICTORIA BRIDGE

Victoria Bridge is located towards the top of Kendal and connects the northern end of Stricklandgate and Sandes Avenue to the eastern side of the River Kent and nearby train station. The bridge was constructed in 1887 to celebrate the Golden Jubilee of Queen Victoria. In 1898 there was a huge flood in Kendal and the river burst its banks, flooding the nearby streets; the water was so high that it could barely pass underneath Victoria Bridge.

36. KENDAL MUSEUM

The current museum was created in 1914 when it moved from Stricklandgate House to its new home on Station Road. The building housing the museum was originally home to the Whitwell & Hargreaves wool warehouse, which was located close to the station for ease of transportation of their goods. The warehouse was even served by its own railway branch line that led across the road to Kendal railway station.

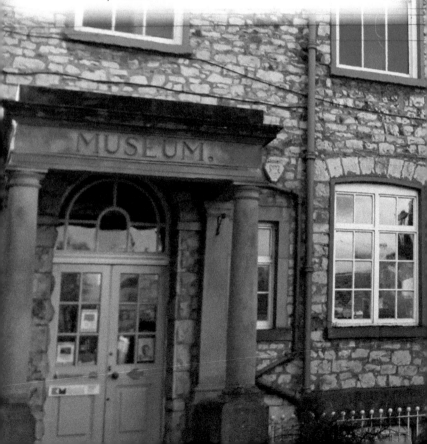

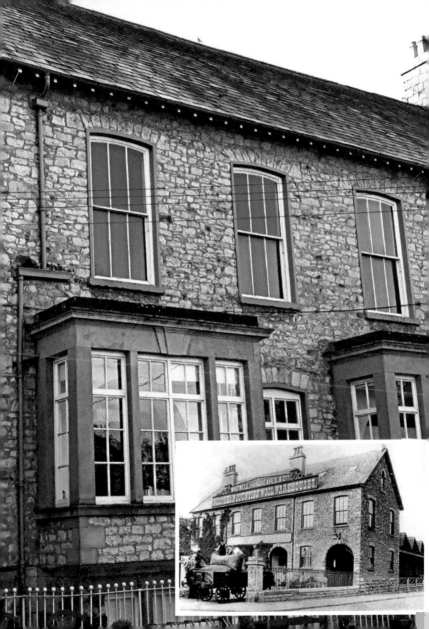

37. KENDAL TRAIN STATION

Kendal has been connected to the railway network since 1847, when the Kendal & Windermere Railway was opened. Originally the station was a wooden construction, but this was replaced in 1860 by the current stone building. The building was almost lost in the 1960s when it was decided that it should be demolished, but this did not happen. In 1973 the railway became a single line in order to save money. By the 1990s the site underwent subsequent renovations and the station nowadays can only be accessed by the nearby ramp.

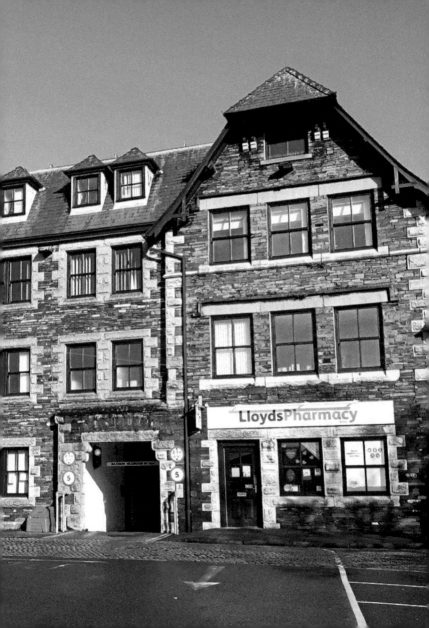

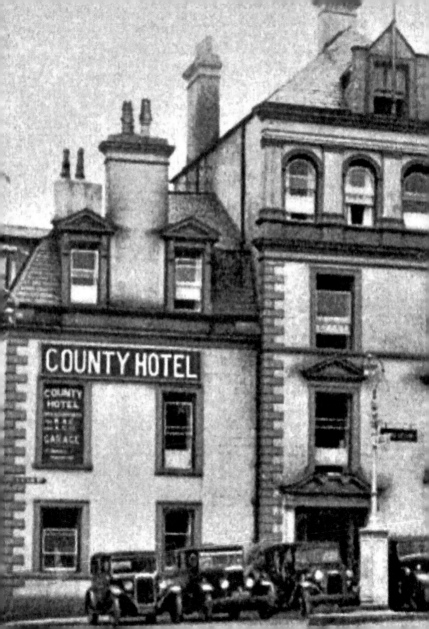

38. THE COUNTY HOTEL

The County Hotel has a long and interesting history as an inn. Some of the earliest records show that in 1611 a building was located on the current site. It was known as the Lowther Arms from 1796 until 1832, when it was renamed the Brougham Arms after James Brougham, the first MP for Kendal. By 1840 it had once again become known as Lowther Arms, until the arrival of the railway in the town when it was renamed the Railway Inn. Since the end of the nineteenth century it has been known by several other names, the Commercial Hotel, Railway Hotel, and Railway & County Hotel. It has been known as The County Hotel since 1910.

39. THE CASTLE DAIRY

The Castle Dairy is one of the oldest surviving buildings in Kendal and until 2003 was the oldest continually occupied residence in the town. The building was constructed during the fourteenth century as a farmhouse and to this day remains relatively unchanged, with the exception of a refurbishment by Anthony Garnett in 1560s.

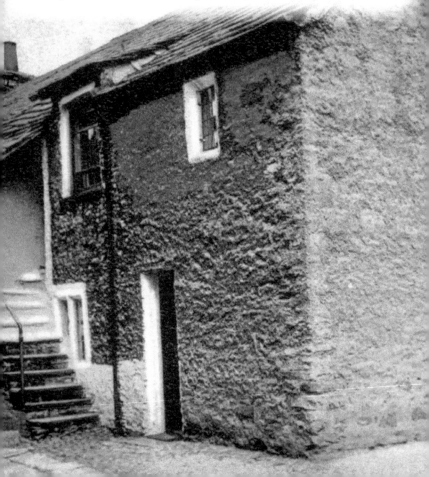

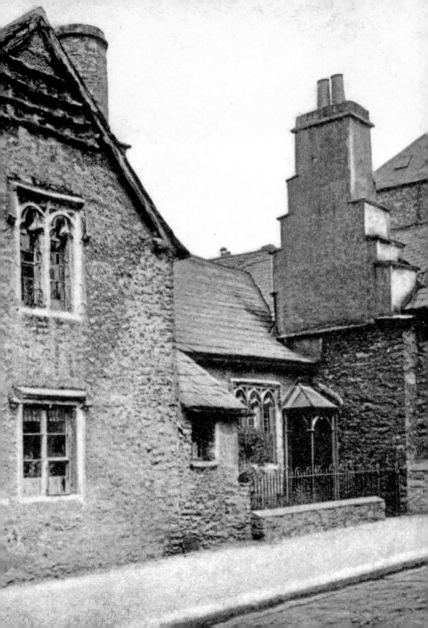

40. STRAMONGATE BRIDGE

The current bridge was constructed in 1794 and incorporates parts of an earlier bridge that dates from the seventeenth century. There was a bridge on the site as early as 1379, with records from the time referring to it as 'de ponte de Strowmondgate'.

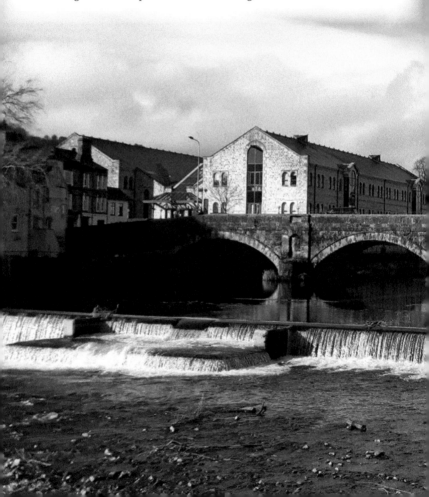

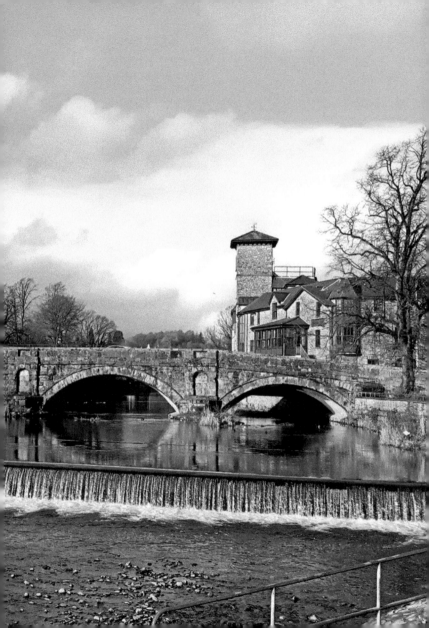

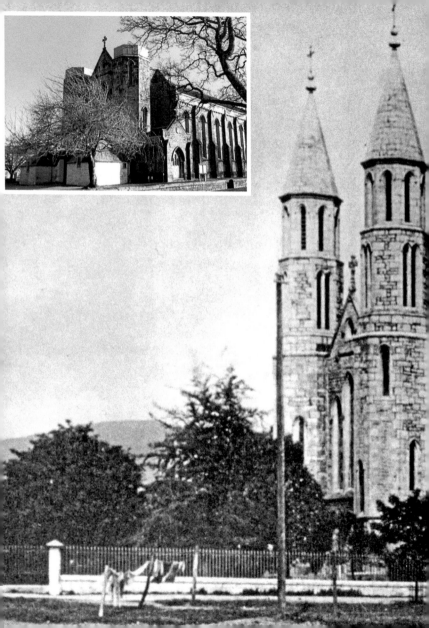

41. ST GEORGE'S CHURCH

The church was built in 1840 to replace the previous St George's Chapel, which had been located on the upper floor of a building in the marketplace since 1754. The original design by local architect George Webster included two magnificent spires. In 1910 Lancaster architects Paley & Austin added a chancel to the church. Unfortunately, by the 1920s the church spires had fallen into a poor state of repair and were removed, leaving the two flat-topped towers that can be seen today.

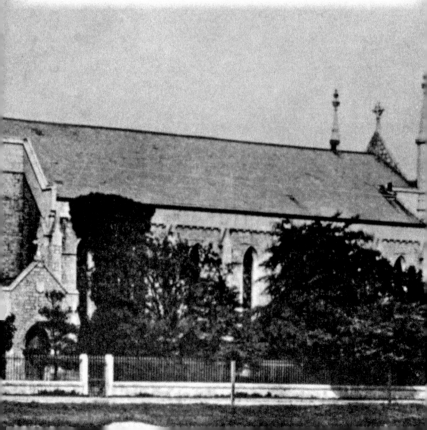

42. GOOSEHOLME

Gooseholme was an important site in the town linked to the processing of wool into sheets. This site was originally surrounded by a mill race that fed water to the nearby mills, giving the area the appearance of an island by the river. The river was used to wash the cloth, which was then stretched on tenter frames while it dried. Several washing platforms and steps still exist by the river side.

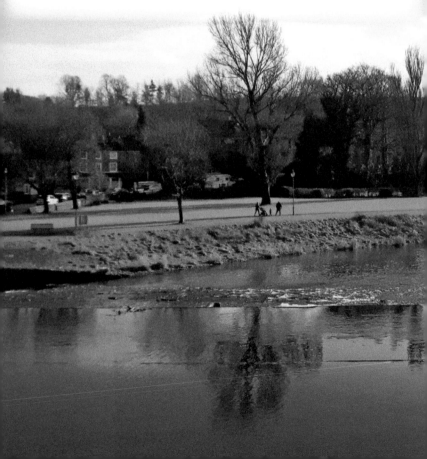

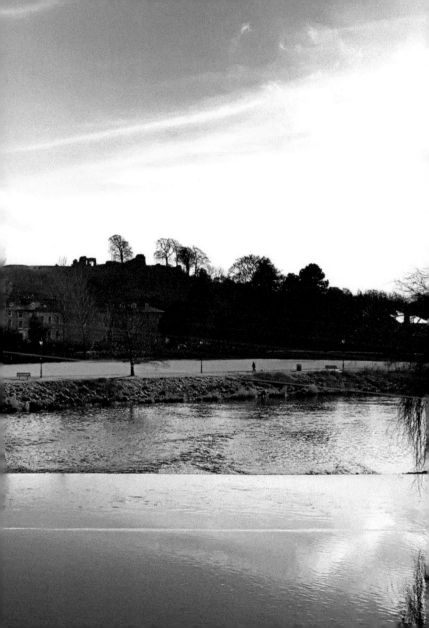

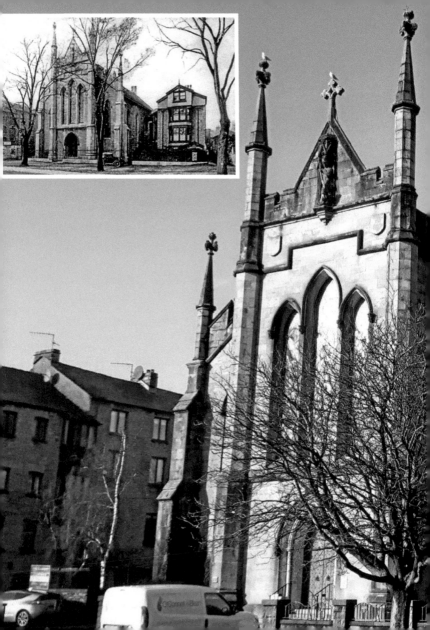

43. HOLY TRINITY & ST GEORGE CATHOLIC PARISH CHURCH

The Roman Catholic Church of Holy Trinity and St George was built between 1835 and 1837. Originally the church was based in a small house on Stramongate that served as a chapel. The new neo-Gothic-style church opened in 1837 and was designed by local architect George Webster. The notable statue of St George and the dragon above the door was designed by Thomas Duckett. The adjoining presbytery has since been rebuilt, but the original convent located to the right of the church was demolished to allow the construction of a new road.

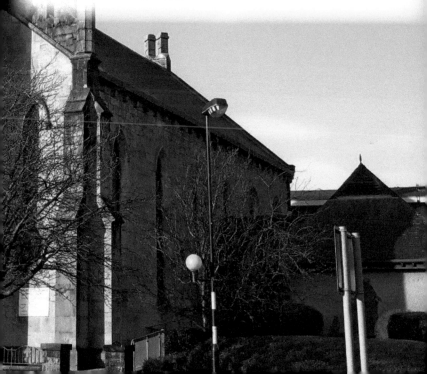

44. KENDAL CASTLE

The castle was built during the twelfth century as a home for the Lancaster family who held the baronial title to Kendal. Most famously the castle held a connection to the Parr family through marriage. During the reign of Edward III Sir William Parr married Elizabeth Ros, who was the heiress of the title. Later on another ancestor, Catherine Parr, married Henry VIII, but by this time the castle was long abandoned and in a poor condition. Since the family left around 1483, the castle has survived only as a ruin. The site was purchased in 1897 by the Kendal Corporation and was given to the town to celebrate the Diamond Jubilee of Queen Victoria.

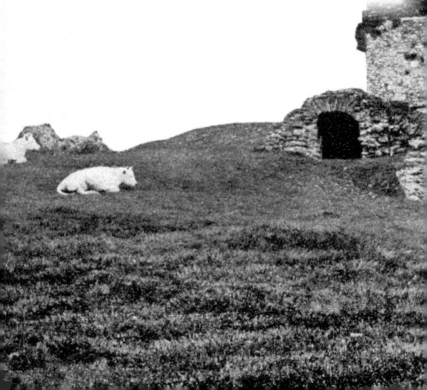

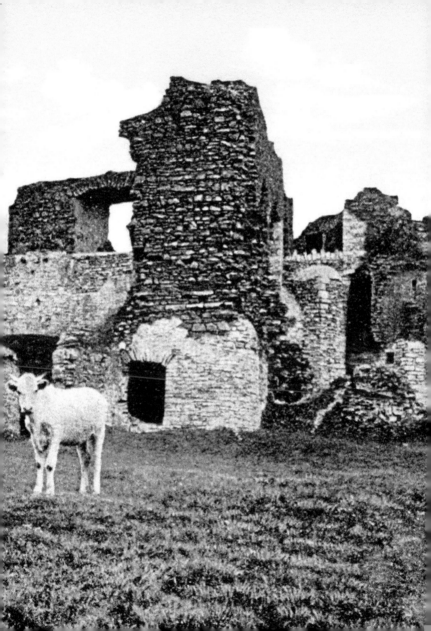

45. WILKINSON'S ORGAN WORKS

Wilkinson's piano and organ works was a major factory within the town, producing various instruments for use in churches and schools around Britain. They were famous for constructing an organ that was housed in the Masonic Hall located in Blackhall Yard. Unfortunately, this building suffered a terrible fire, but the organ survived and was rebuilt in the new Masonic Hall on Station Road, located between the County Hotel and Kendal Museum.

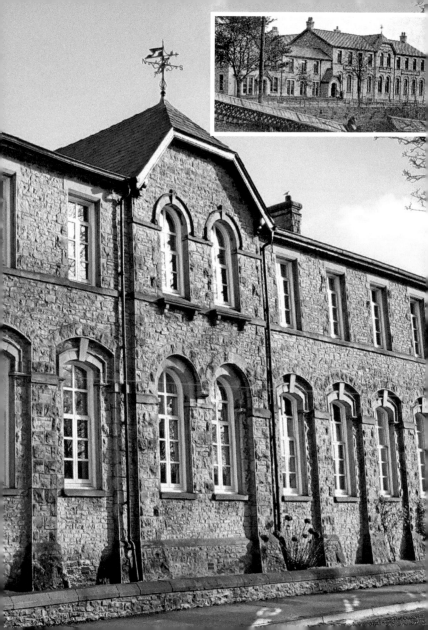

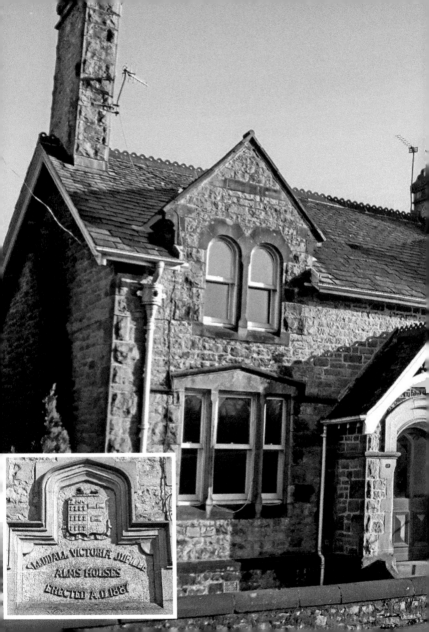

RANDALL VICTORIA JUBILEE
ALMS HOUSES
ERECTED A.D 1887

46. SLEDDALL CHAPEL AND ALMSHOUSES

The most famous feature of Aynam Road are the impressive almshouses and chapel, built by John Sleddall in 1887 at a cost of £4,250. They were constructed to commemorate the Golden Jubilee of Queen Victoria. In 1986 the adjoining chapel was made into two additional houses. Aynam Road nowadays is the main route southwards out of Kendal and follows the route of the River Kent towards Nether Bridge.

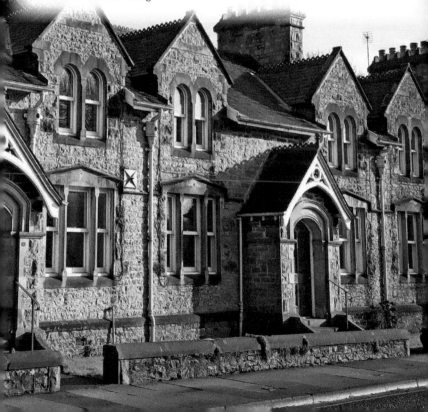

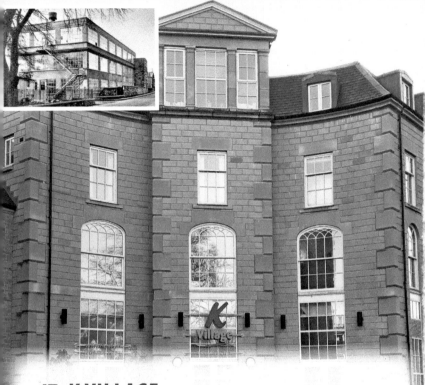

47. K VILLAGE

Kendal has always had an economy based on manufacturing and it was during the nineteenth century that the shoe industry was born in the town. In 1842 John Somervell and Robert Miller created the company that would go on to become K Shoes, a business that until 1978 was still family owned and a large local employer. In 1981 the company was struggling and merged with Clark's shoes, while keeping its own brand name. Over the next decade many of the offices were closed in the area and manufacturing was reduced, with the last shoes being made in Kendal in 2003. The site of old factory was demolished and its namesake, K Village, was built on the site, housing a new shopping centre and residences.